Indian paintings
from Oxford collections

Andrew Topsfield

Ashmolean Museum
in association with the Bodleian Library
Oxford
1994

Titles in this series include:
Drawings by Michelangelo and Raphael
Ruskin's drawings
Camille Pissarro and his family
Oxford and the Pre-Raphaelites
Worcester porcelain
Italian maiolica
Islamic ceramics

Cover illustration: *Lovers at Daybreak, c.*1675, plate 20

Designed by Cole design unit, Reading
Set in Versailles by Meridian Phototypesetting Limited
Printed and bound in Singapore by Toppan Printing Co.

To Helen

Note
The author is grateful to the staff of the Bodleian Library,
in particular Doris Nicholson, for their kind assistance
in the preparation of this book; to Robert Skelton and
Mark Zebrowski for their help, and to Julie Meisami for
identifying the text of *Husn o Dil* (**4**).

A.T.

Introduction

The University of Oxford has the distinction of owning what are probably the earliest major examples of Indian sculpture and painting to have entered any Western museum or library. In 1686 Sir William Hedges, governor of the East India Company in Bengal, presented to the newly founded Ashmolean Museum a Pala stone image of the god Vishnu, which he is thought to have obtained on a boating trip to Sagar island at the mouth of the Ganges. Half a century earlier, Archbishop Laud, Vice-Chancellor of the University, had presented to the Bodleian Library an album of Indian paintings, including eighteen ragamala illustrations to musical modes (**10**). How Laud or his agents acquired this album is unknown. It was part of his last great benefaction to the Library in 1640, a few months before his final imprisonment in the Tower of London.

It took the University another two centuries to make further significant acquisitions of Indian sculpture. Aesthetic prejudice conditioned by Greco-Roman ideals was no doubt partly responsible. But Mughal illustrated manuscripts and painting albums were more immediately attractive, portable and readily available to interested Company officials stationed in the old provincial capitals of northern India and the Deccan. Many such volumes eventually found their way to the Bodleian, especially in the nineteenth century. Some came with the huge bequest of the antiquary and bibliophile Francis Douce in 1834. More came a few years later from the collections formed in India and Persia by the diplomat Sir Gore Ouseley and his brother William, both of them able Persian scholars. Some of the Ouseley manuscripts had been purchased

after the death of Sir Gore in 1844 by another collector, J.B.Elliott, a Bengal civil servant residing at Patna, who presented them to the Library along with his own collection in 1859. The outstanding item in this gift was the magnificent manuscript of the *Baharistan* prepared for the Emperor Akbar (**6–7**).

Although few acquisitions have been made in the twentieth century, the Bodleian now has one of the most important Mughal collections in the world. Since the 1950s an Indian painting collection has also been established in the Ashmolean Museum's Department of Eastern Art (before 1963, the Museum of Eastern Art in the old Indian Institute). Although much smaller than the Bodleian collection, it is to some extent complementary in its representation of the Rajput schools, which in most cases have only become widely known within the last forty years.

From this long history of sporadic collecting Oxford is able to show a rich variety of the main types of Indian painting from the eleventh to the late nineteenth century: from Pala Buddhist paintings on palm-leaf to the Kalighat bazaar pictures of 1880s Calcutta or an oil-painting on a classical literary theme by the academicist Ravi Varma. But the main strength of the collections, and of the Bodleian's especially, lies in imperial or provincial Mughal painting, with a strong historic emphasis on the eighteenth century schools. A book of this size can offer only a small sample of such diverse collections. The present selection is restricted to the Mughal, Deccani and Rajput schools up to *c.*1800, with some bias towards the first, and most inspired, century of Mughal painting (*c.*1560–1660), from the reign of Akbar to the fall of Shah Jahan.

Akbar (1556–1605), greatest of the Mughal emperors, was a ruler of boundless energy who personally encouraged the development of the Mughal style, from a brilliant synthesis of Persian technique, Indian vitality and European naturalism. The earlier work of his reign (**1–3**) shows a transformation

of the delicate Persian idiom by the vigour of the mainly Indian artists recruited to the imperial studio. Later productions show greater refinement and individualism, as seen in the very different reworkings of European subjects by Kesu Das and Abu'l Hasan (**5, 8**) and in the pages contributed by Basawan and Miskin to the *Baharistan* manuscript of 1595 (**6–7**).

Under Jahangir (1605–27), a gifted connoisseur, this refining process continued. The art of portraiture, introduced to India by the Mughals, reached its highest development, represented here by the famous painting which the Emperor commissioned of a dying courtier (**9**). Shah Jahan (1627–58) was above all a lover of jewels and marble monumental architecture, as famously embodied in the Taj Mahal. The painting of his reign is technically excellent but frigid in tone. Pomp and protocol prevail over intimacy (**13–15**). New creative impulses were lacking in Mughal art after this point, and under the puritanical Aurangzeb the imperial studio became largely dispersed.

During the seventeenth century painting also flourished, under increasing Mughal influence, in the still independent Deccani Sultanates of Bijapur and Golconda (**12, 17**). The Hindu chiefs of the Rajput kingdoms, who served for long periods at the Mughal court or in the imperial armies, also patronised artists trained in the Mughal style (**17–18**). But usually the refined foreign idiom soon became assimilated to the bolder conventions of indigenous Rajput painting (**11**). Among the most conservative patrons in this respect were the Maharanas of Mewar, the premier Rajput chiefs, who had been the last to capitulate to the Mughal power (**21–22, 37**).

After the death of Aurangzeb in 1707 the Mughal empire gradually broke up. His successors were ineffectual puppets or hedonists. The most enduring of them was Muhammad Shah (1719-48), known as Rangila, 'the Pleasure-loving'. Deficient as a statesman and general, he was a devoted patron

of poetry, music and painting (**23–25**). In 1739 he endured the humiliating invasion and sack of Delhi by Nadir Shah of Persia. At the same time, the provinces of Oudh (Avadh), Bengal and Hyderabad became virtually independent kingdoms, whose rulers gave lavish patronage to artists of all kinds, many of them migrants from Delhi. The sybaritic Nawabi culture of Lucknow and Faizabad in particular gave rise to a prolific, if often vapid, offshoot of late Mughal painting. Illustrations to literary romances retained their popularity, as well as conventional scenes of nobles and ladies consorting on terraces, watching dancing-girls or visiting holy men in forest groves (**29–31**). Some later examples of these genres were transformed by playful experiments with European effects such as perspective (**32–33**).

Other Mughal-trained artists found their way north and westwards to the as yet isolated and traditionalist Rajput courts. In the Punjab Hills a very influential family of artists, of whom Nainsukh is the most famous, worked at Guler and other courts from around the mid-eighteenth century. They achieved a brilliant transformation of the local pictorial traditions, combining Hindu poetical and devotional feeling with Mughal observation and finesse (**34–35**).

By the late eighteenth century the Mughal empire was moribund, and in eastern India and elsewhere artists began to turn for patronage to the officers of the British East India Company. The Europeanised style which resulted gave rise to much mediocre mass-production, but also to some exceptionally fine work. The masterly study of a sarus crane, painted by Shaikh Zain ud-Din for Lady Impey (**38**), follows a European convention of natural history illustration, while still recalling the Mughal tradition of bird painting going back to the time of Jahangir.

1 Amir Hamza defeats 'Umar-i Ma'di Karab

An illustration to the *Hamzanama*
Mughal, early 1560s
Gouache on prepared cloth, with text panels on
paper; 67 × 49.5 cm
Ashmolean Museum (EA 1978.2596; *Gift of
Gerald Reitlinger*)

The *Hamzanama* was one of the first Mughal illustrated
manuscripts, and by far the most ambitious. It originally
comprised 1400 large paintings on cotton cloth, of which
just over a tenth survive. Its subject is a rambling story-
cycle of fantastic adventures attributed to Amir Hamza,
uncle of the Prophet Muhammad. Hamza's many
triumphs over dragons, demons and sorcerers greatly
appealed to the young Emperor Akbar. This project kept
his newly recruited studio busy for fifteen years.

In this early page from the series Hamza confronts
a giant infidel warrior in battle. The youthful Amir top-
ples his opponent with heroic ease: 'Umar-i Ma'di Karab
pressed his horse into the middle of the battlefield and
charged towards Amir [Hamza]. The Arab Amir waited
until he drew near, then took one foot from his stirrup and
kicked that champion's horse in the side. Horse and rider
turned a somersault, and cheers and cries from both sides
reached to the sky.[1]

Tumbling headlong, his lance broken and his
arrows spilling, 'Umar-i Ma'di Karab clearly never stood
a chance. The onlookers may well 'bite the finger of
amazement'. But even in defeat he remains a sympathe-
tically noble figure, for after this he is converted to Islam
and becomes one of Hamza's close companions.

The earliest *Hamzanama* pages were painted
under the direction of the Persian master Mir Sayyid 'Ali
and tend to be more restrained than the dynamic, often
violent, later compositions. Here the ranks of horsemen
and the high rocky skyline with a stylized tree are treated
in a Persian manner, while the spirited musicians in the
background are more distinctively Indian.

[1] Z.Faridany-Akhavan,
*The problems of the
Mughal manuscript
of the Hamza-
nama, 1562–77: A
reconstruction*, Ph.D
diss., Harvard Univ.,
1989, pp. 238–39

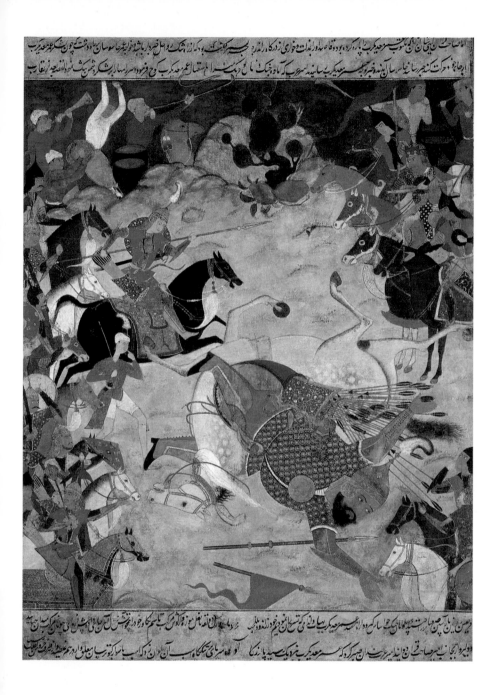

9

2 Court scene with Chaghatai dancers

Mughal, *c*.1565
Gouache with gold on paper; 23.1 × 15.5 cm
Bodleian Library (MS Douce Or.b.1, f.12b)

A ruler, probably the young Akbar, receives two noble-men who are introduced by an elderly courtier, beneath a richly ornate canopy. Attendants stand on either side, while in the foreground a spirited group of dancers and musicians provide the Emperor's entertainment. The dancing-girls with castanets and their tambourine-players wear the plumed head-dresses of the Chaghatai Turks of Central Asia, whence Akbar's grandfather, Babur, had come forty years earlier to conquer northern India.

 The lively informality of this court scene is typical of early Mughal painting under Akbar. A composition deriving from Persian painting, with figures disposed broadly in a circle, is reworked with brio. Some signs of European influence appear in the varied postures of the figures and the modelling of robes and dresses. The tiled courtyard with its characteristic interlocking stars and hexagons makes a boldly vibrant background for the central trio of dancers.

 Such scenes provided models for the next gener-ation of Mughal artists when depicting the life of Akbar and his Timurid ancestors in the great history manu-scripts, such as the Victoria and Albert Museum *Akbarnama* of *c*.1590. There the raw and mouvementé qualities of the earlier work were overlaid by greater compositional elaboration and a more homogeneous refinement of technique.

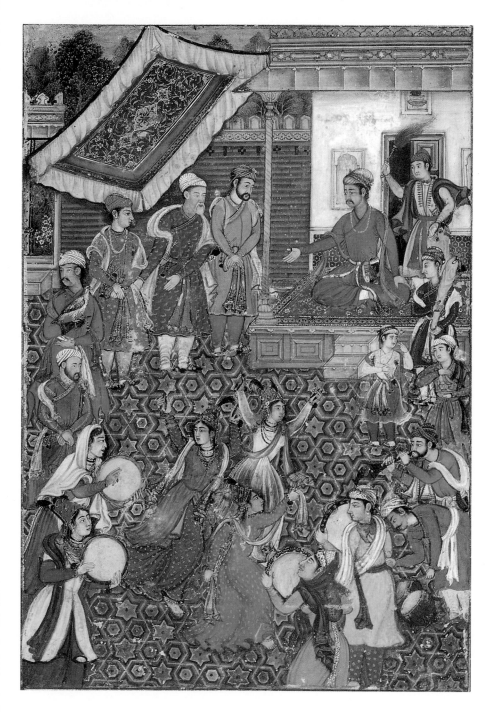

3 A prince and maid with wine-cup
Mughal, *c.*1575–80
Gouache with gold on paper; 13.7 x 8.8 cm
Bodleian Library (MS Douce Or.b.1, f.6v.)

On a garden terrace, tiled with hexagon and star forms, a prince accepts a wine-cup from a maid or concubine. Absorbed in reverie, his head inclined as he smells a flower sprig, he extends a hand which appears to touch hers. His splendid brocade robe bears swirling floral arabesques; her six-pointed dress is of a sheer yellow. The pavilion behind, with its thin sandstone pillars, arabesque carpet, wine-flasks in niches, half-furled curtain and half-open door to an inner chamber, suggests a mood of amorous expectancy; as does the luxuriant garden behind the high red railings, with its slender cypresses paired with sinuous flowering trees and shrubs.

While the prince resembles Akbar in early manhood, both figures are more likely idealised types. Such conventional scenes of the dignified private enjoyment of worldly pleasures are common in the Indo-Persian tradition (**16**), though less so in Akbar's reign than robuster scenes of public action in durbar hall, hunting-field or battleground.

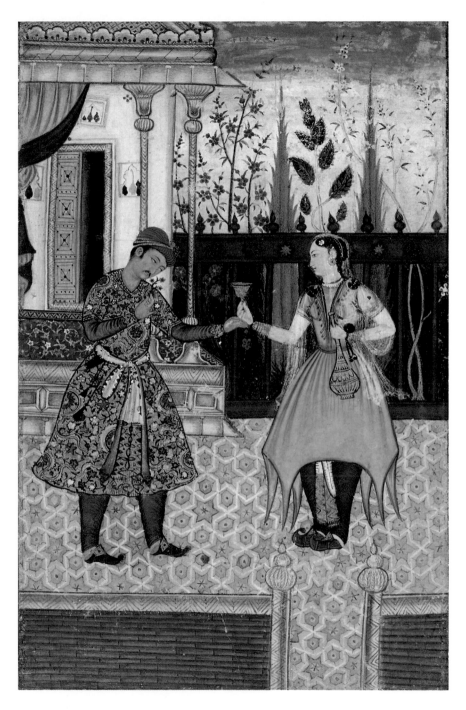

4 Beauty is shown the image of Heart

An illustration to *Husn o Dil* by Fattahi Nishapuri
Mughal, *c.*1570–75
Gouache with gold on paper; 27 x 19.5 cm
Bodleian Library (MS Pers.b.1, f.28v)

Husn o Dil or 'Beauty and Heart' is a Persian prose
romance dating from the 1430s. It is an allegory, imbued
with Sufi mysticism, in which the human faculties or
parts of the body are personified in a tale of princely
lovers, symbolising the quest for union with the divine.
Heart (Dil), a prince of the West and governor of the city
of Body, conceives an ardent desire to discover the
miraculous Water of Life. His emissary, Vision, travels
the world in search of it. He eventually arrives in the
Eastern kingdom of Love, whose daughter Beauty
(Husn) dwells in a garden where the Water of Life flows.
It so happens that this princess possesses a fine carved
image whose subject is a mystery to her. Vision immedi-
ately recognises it as a portrait of his master: ...address-
ing Beauty, he said, 'This is the likeness of a Prince in the
West, whose name is Heart, and whose beauty and
accomplishments are universally spoken of. Vision having
given this description of Heart, Beauty fell violently in love
with him, though she had never seen his person.'[1]

Beauty then sends her servant with her ruby seal
to bring Heart to her. After many further adventures, the
lovers are at length united.

In this Akbar period illustration the portrait of
Prince Heart is shown not as a sculpture, as the text
describes, but – more in keeping with Mughal tradition
– as a miniature painting. The elegantly attenuated archi-
tecture is a fairytale version of Akbar's palace city of
Fatehpur Sikri, built in the 1570s. Behind Beauty's gold
hexagonal throne are wall-paintings of winged fairies
among floral arabesques. Yet the Water of Life is seen
flowing in a typical Mughal sandstone watercourse and
fountain, and the melon-seller and others outside the
gate would have been familiar street figures of Fatehpur
or Lahore.

[1] *Husn oo Dil, or Beauty
and Heart, a pleasing
allegory in eleven
chapters, composed by
Alfettah of Nishapoor,*
trans. W. Price, London,
1828, p.13 et seq

14

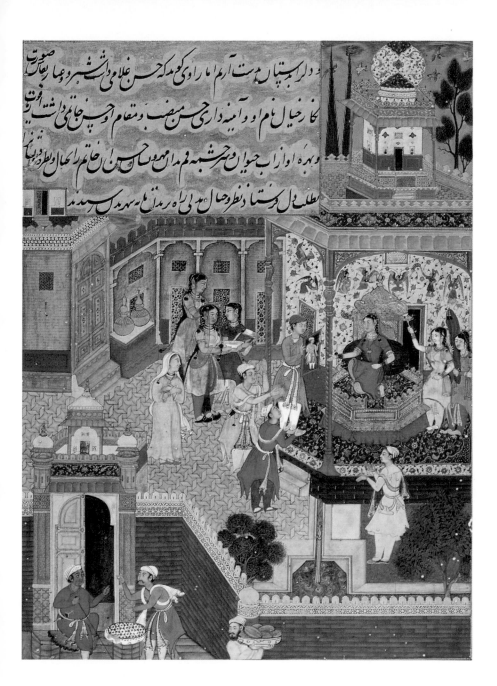

15

5 St Matthew the Evangelist

Mughal, 1588. By Kesu Das, from an engraving
by Philip Galle after Maerten van Heemskerck
Gouache on paper; 18.6 × 11.2 cm
Bodleian Library (MS Douce Or.a.1, f.41v.)

Akbar became fascinated by the European pictures,
many of them engravings of Christian subjects, which
reached his court through traders and Jesuit mission-
aries in Goa. His interest was fired as much by their
manner as their content. Western naturalistic tech-
niques had a sensational impact on sensibilities attuned
to Persian art. Akbar soon encouraged his own artists to
imitate and adapt these foreign models.

Fig. 1 St Matthew the
Evangelist. Engraving
by Philip Galle after
Maerten van
Heemskerck. (After
M.C.Beach, 'The Mughal
painter Kesu Das',
Archives of Asian Art,
XXX, 1976-77).

Kesu Das was a prolific copyist of European sub-
jects. He is not accorded first rank status in Abu'l Fazl's
account of Akbar's studio – he lacked the flair of a
Basawan (**6**) – but he is the leading painter of the second
rank. His qualities are best seen in *St Matthew*, remark-
able for its accomplished technique and expressive
reworking of a religious theme quite alien to a Hindu
artist.

The source engraving, after Maerten van
Heemskerck, depicts St Matthew writing his Gospel (fig.
1). The attendant angel holds the volume across a knee
resting on the Evangelist's thigh. Kesu shows a broad
fidelity to the complex drapery folds in the engraving,
with a confident mastery of highlight and shadow; he
revels especially in the saint's vivid lapis-blue robe. But
the strong characterisation of the original faces is soft-
ened, in accordance with Mughal taste. The angel's
severe profile becomes a gentler, generalised feminine
type seen in three-quarter view, with wing-feathers also
more pacifically down-turned. The interaction of the two
figures is more restrained and serene.

The strong colouring of the costumes is comple-
mented by a setting in muted blue-green tones. The
background is extended to conform to the vertical page
format. The conventional shore scene in the print is
replaced by an Indian lotus lake and forest with a
European townscape beyond. The saint's pavilion, with
a bookishly opulent interior, is also a hybrid of Mughal
and European forms. The foreground contains flower-
beds, a cat (common in European subjects by Mughal
painters) and exotic ornate vessels; the ewer on the right
bears the artist's name and date.

16

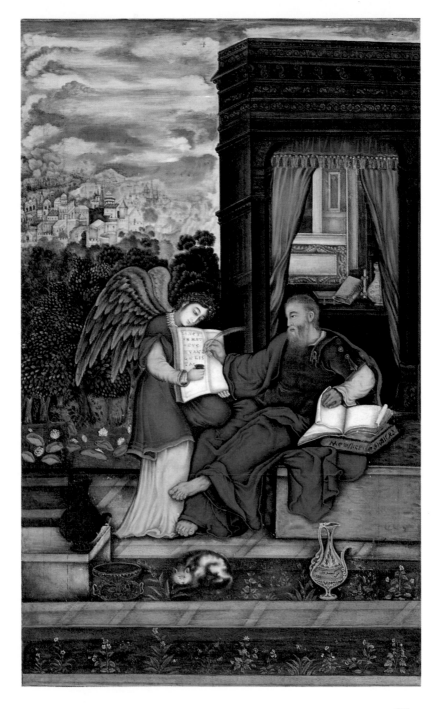

6 The vain dervish rebuked

An illustration to the *Baharistan* of Jami
Mughal, 1595. By Basawan
Gouache on paper; 19.7 × 12.5 cm
Bodleian Library (MS Elliott 254, f.9r)

On seeing a dervish artfully darning and redarning his ascetic's robe, the learned and saintly Abu'l Abbas Qassab declared, 'That garment is an idol to you.' This anecdote against vanity comes from a fifteenth century Persian classic, the *Baharistan* ('Garden of Spring') of Jami. The illustration, from a splendid manuscript prepared for Akbar at Lahore in 1595, is by Basawan, one of the greatest Mughal painters.

Basawan refined his skills through a close study of European methods of modelling and recession, seen here in the interior detailing of the chamber, gateway and windows. But as a true master he used his technique to original expressive effect. He interprets Jami's story with a subtly worked contrast of the two main figures. The vain dervish, with his dark dress, greyish skin and fingers crooked over his distended, empty robe, appears as though shadowed by worldly attachment. Abu'l Abbas Qassab, the true Sufi, with his pale, translucent skin and radiant blue robe, speaks with the authority of spiritual illumination. He accompanies the rebuke with a gesture of the left hand, while holding his prayer beads in his right.

The setting reveals many delightfully observed details: the gnarled and twisted tree with agile, climbing squirrels; the blithe goats with a suckling kid, beside the flowing well-spring; and, turning its back to the false dervish, the proudly strutting peacock on the palace eaves. Above, a man carrying a net seems to point towards the birds flying and nesting; this may be another comment on human vanity.

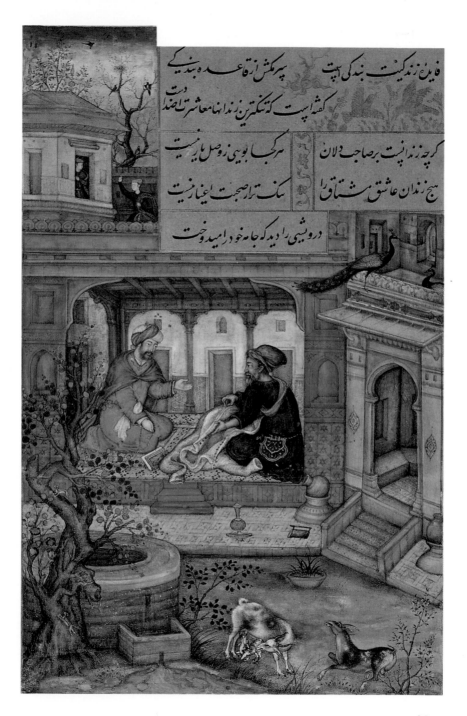

فاین زندکیت بندکی اپت پس همکش ازقاعده بندی کی

کفته اپت که تنگترین زندانها معاشرت اضدا دست

که چه زندانست برصاحب دلان هرکجا بویی زوصل یار نیست

هیچ زندان عاشق مشتاق را تنگ ترازصحبت اغیار نیست

درویشی رادید که جامه خود را امید دوخت

19

7 **While lovers meet, the friend is beaten**
An illustration to the *Baharistan* of Jami
Mughal, 1595. By Miskin
Gouache on paper; 24 × 13.5 cm
Bodleian Library (MS Elliott 254, f.42v.)

In this tale from the *Baharistan*, the illicit lovers Ashtar
and Jayida, who were of different tribes, contrive to
meet by night outside her camp. Ashtar's loyal friend,
disguised in Jayida's clothes, takes her place in her hus-
band's tent. When the husband comes to offer milk to his
supposed wife, the friend acts coquettishly and spills it.
The husband then beats him furiously until the mother
and sister of Jayida intervene, as shown here. However,
the friend's imposture remains undetected and he has
the consolation of spending the rest of the night with
Jayida's sister. The moral, says Jami, is that in the hour
of need a true friend is indispensable.
 The nocturnal landscape is treated by Miskin with
a deep and subtle palette, influenced by European
chiaroscuro effects. The complex composition retains
the high viewpoint of Persian painting, disclosing a suc-
cession of skilfully integrated and sensitively observed
scenes, especially of animal life, at which Miskin
excelled. The adulterous drama is an interlude in a
natural idyll, both serene and mysterious. The furtive-
looking couple at their tryst are flanked by somnolent
riding-camels and, further off, by restlessly plunging
horses. Among the bulbous tents with their billowing
drapes are various dozing sheep and goats and a ten-
derly observed cow and calf with a herdsman, based on
a European model. All except the dog ignore the com-
motion outside the irate husband's tent. The tent itself
is alive with brocaded scenes of birds and a leopard
chasing deer, while Miskin's artful rock formations
(recalling both Flemish and Persian example) sprout
concealed grotesque faces.

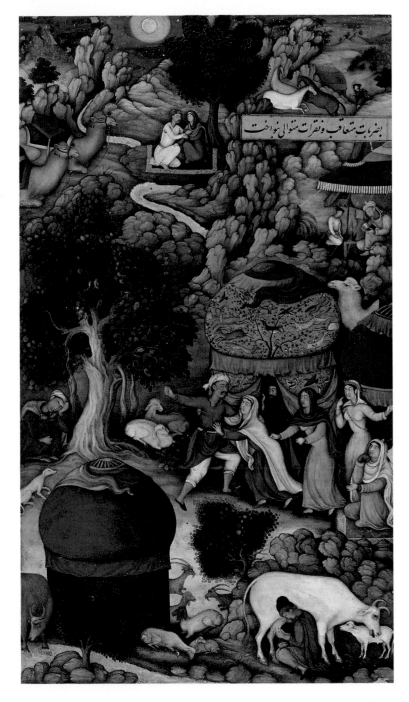

21

8 St John the Evangelist

Mughal school, 1600. By Abu'l Hasan, after an engraving of the Crucifixion by Albrecht Dürer of 1511
Brush drawing with light tinting on paper; 10 × 4.6 cm
Ashmolean Museum (EA 1978.2597; *Gift of Gerald Reitlinger*)

This small but powerful brush-drawing of the figure of St John from a Dürer engraving (fig. 2) is the earliest known work by Abu'l Hasan (fig. 3), one of the most gifted artists working for Prince Salim, later the emperor Jahangir (1605–27). Eighteen years later Jahangir was to write of him, 'At the present time he has no rival or equal... From the earliest days I have always looked after him, till his art has arrived at this rank. Truly he has become Nadir-i Zaman ('The Wonder of the Age').'

The drawing of *St John* was executed in 1600, when Abu'l Hasan was only twelve. Together with his father, the Persian artist Aqa Riza, he was already in the service of Prince Salim, then in revolt against his father Akbar and residing at Allahabad. His version of Dürer's saint may have originated as a copyist's exercise, but the result is more a reinterpretation. He had clearly already mastered the techniques adapted by earlier Mughal painters from European prints. Despite occasional tentativeness in his brush-drawing, he confidently suggests volume through outline and shaded modelling, skilfully translating the great German engraver's linear hatching into the painterly medium of wash. The Evangelist's draped figure consequently has a delicate quality which brings into stronger relief his youthful, anguished face among serpentine curls. This look of disquiet is different in kind from the expression of conventional grief seen in Dürer's figure, with its up-turned gaze and more acute tilt of the head. By uniting these qualities of naturalism and psychological insight, Abu'l Hasan became within a few years the foremost portraitist at the Mughal court.

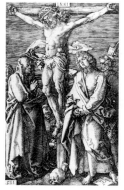

Fig. 2 The Crucifixion. By Albrecht Dürer, 1511. From the *Small Engraved Passion.* Ashmolean Museum.

Fig. 3 Portrait of the painter Abu'l Hasan. By Daulat, *c.*1605–9. From the border decoration of the Gulshan Album, Gulistan Palace, Tehran. (After Y.Godard, 'Les marges du murakka' Gulshan', *Athar-e Iran,* I, 1, 1936).

9 The dying 'Inayat Khan

Mughal school, 1618
Gouache on paper; 12.4 × 15.4 cm
Bodleian Library (MS Ouseley Add. 171, f.4v.)

This chill and moving study of a dying courtier is one of the most famous of all Mughal portraits. Wasted by his opium addiction and alcoholism, 'Inayat Khan was brought before Jahangir to obtain leave to journey to Agra, on the day before his death. The Emperor was both appalled and fascinated by his condition. He described the occasion in his memoirs: On this day news came of the death of 'Inayat Khan. He was one of my intimate attendants. As he was addicted to opium, and when he had the chance, to drinking as well, by degrees he became maddened with wine. As he was weakly built, he took more than he could digest, and was attacked by the disease of diarrhoea, and in this weak state he two or three times fainted. By my order Hakim Rukna applied remedies, but whatever methods were resorted to gave no profit...

They put him into a palanquin and brought him. He appeared so low and weak that I was astonished. 'He was skin drawn over bones'. Or rather his bones, too, had dissolved. Though painters have striven much in drawing an emaciated face, yet I have never seen anything like this, nor even approaching it. Good God, can a son of man come to such a shape and fashion? As it was a very extraordinary case I directed painters to take his portrait. [1]

The artist too was clearly moved by the scene of human extremity. This painting and the preparatory brush-drawing in Boston (fig. 4), even starker in its rendering of the debilitated physique, have been attributed by Prof. S.C. Welch to the master Govardhan. Both pictures in different ways convey the same intense pathos. Here the subdued white, grey and tan tones of the interior complement the deadened colours of the cushions, garments and coverlet. The background composition, with a palely insubstantial carpet and bottles in niches and a thin decorative arabesque panel acting as counter-balance, resembles a washed-out Mondrian in its rectangular formality. Shading round the looming silhouettes of the cushions and the wall and niche surrounds give them a shimmering, phantasmagoric quality.

The dominant image remains the emaciated pallour of 'Inayat Khan's face, torso and hands. His wintry blue eye (reflecting the eau-de-nil cushion) stares in profile, like a courtier still at attention before the Emperor, yet also with the poignant fixity of ultimate resignation.

Fig. 4 The dying 'Inayat Khan. Brush drawing, Mughal, *c.*1618. 9.5 × 13.3 cm. *Courtesy, Museum of Fine Arts, Boston (Francis Bartlett Donation of 1912 and Picture Fund).*

[1] *The Tuzuk-i Jahangiri or Memoirs of Jahangir,* tr. A. Rogers and H. Beveridge, repr. Delhi, 1968, II, pp.43-44

24

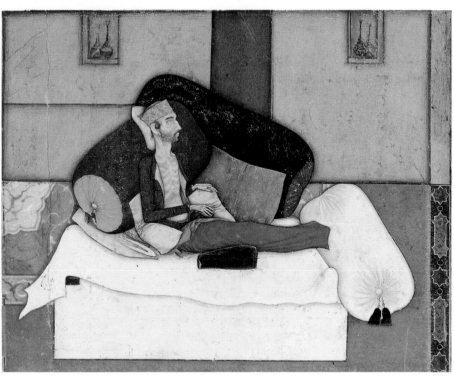

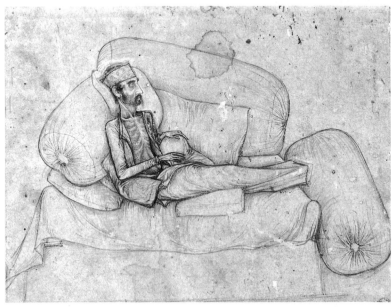

10 A girl snake-charmer

From the Laud Ragamala: an illustration to the
musical mode Asavari ragini
Sub-imperial Mughal style, c.1615. Attributed to
Fazl
Gouache with gold on paper; 15.1 × 10.6 cm
Bodleian Library (Laud MS Or. 149, f.19r.)

From the sixteenth century, ragamala ('Garland of
ragas') became one of the most popular pictorial sub-
jects in Northern India and the Deccan, uniting the main
court arts of music, poetry and painting. The essential
quality of each of the ragas (musical modes) and their
associated raginis (or 'wives') was evoked in Sanskrit or
Hindi verses and depicted in paintings, according to
established conventions. A full ragamala comprised
thirty-six or more pictures. This is one of eighteen sur-
viving pages from an early seventeenth century series,
which belong to a historic album presented to the
Bodleian by Archbishop Laud in 1640.

Asavari is a plaintive mode, said to originate in a
snake-charmers' melody and usually performed in the
early morning hours. The ragini is depicted as a dark-
skinned tribal girl wearing a skirt of leaves. She dwells
alone in mountain forests, where her presence charms
the snakes down from the sandal-trees. Garlanded with
snakes, she sits on a rock from which a stream gushes.
In the absence of her lover, she communes with the
entranced cobra held in her hand.

The colours are mostly subdued, and birds, rocks
and vegetation are reduced to simplified, rhythmical
forms. This style is typical of those lesser Mughal artists
of the early seventeenth century who fell short of
imperial standards but found commissions with Hindu
and Muslim courtiers. The Laud Ragamala pages have
recently been attributed to Fazl, who is known to have
worked for the leading sub-imperial patron, 'Abd
ul-Rahim Khan-i-Khanan, commander-in-chief of the
Mughal armies.

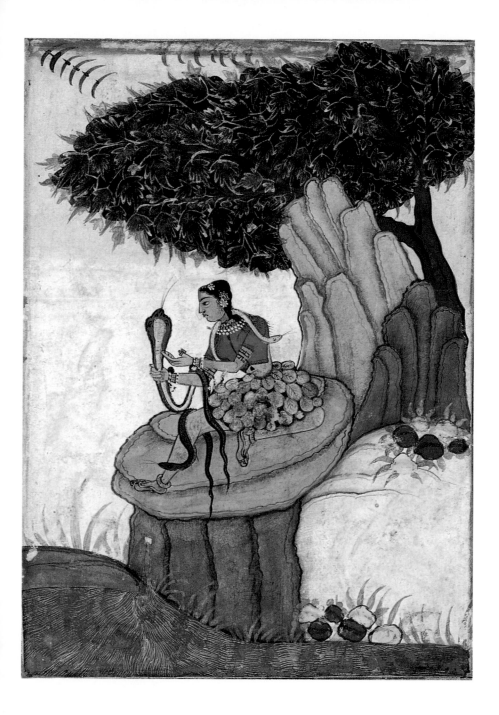

11 An ascetic by a lotus pool
Illustration to the musical mode Devagandhara ragini
Bundi, Rajasthan, c.1650
Gouache with gold on paper; 21.9 × 12.4 cm
Ashmolean Museum (*Mrs M. Barrett Loan*)

The musical mode Devagandhara, performed in the morning after sunrise, is conceived as a solitary lady whom the pain of separation from her lover has transformed into an emaciated ascetic. Here only the yogi's jewelled ornaments reveal a vestige of his femininity, though the domed pavilion standing for his hermitage is more like a palace bed-chamber. Its projecting finial in the form of a makara (aquatic monster) holding a bright orange-red pennant symbolises the love-god Kama. Signs of natural fecundity abound, with banana and mango trees, harmonious pairs of cranes and ducks, and flowering lotuses. The yogi sits apparently withdrawn, telling his prayer-beads inside a *gomukhi* bag while toying with a stray strand of hair. This ragini exhibits a commonly found tension between the erotic and ascetic moods, between sensual enjoyment and holy renunciation.

At Bundi and its near neighbour Kotah in southeast Rajasthan numerous series of ragamala pictures were produced, both in wall-paintings and on paper. They derive iconographically from a dispersed ragamala, painted in 1591 at Chunar near Benares by artists trained at the Mughal court, which must have been in Bundi possession at this date or not long after. Indigenous Bundi painters interpreted the same subjects in their own robust style, often, as here, recreating the given theme with a strong flavour of the appropriate *rasa* or mood.

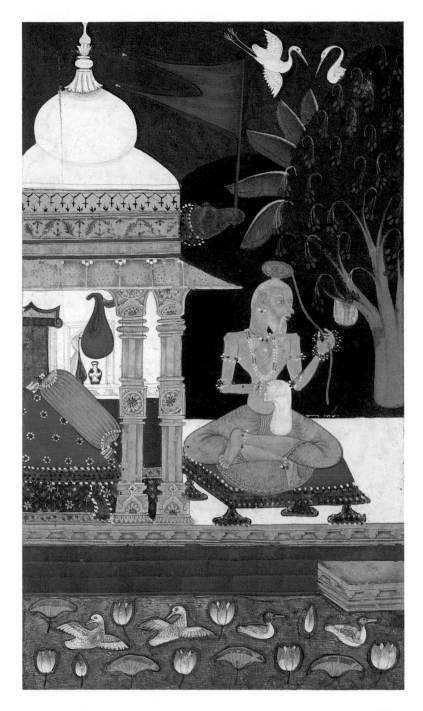

12 A dervish receiving a visitor
Bijapur, Deccan, c.1610–20
Gouache with gold and silver on paper;
25.8 × 19.5 cm
Bodleian Library (MS Douce Or.b.2, f.4v.)

In this masterpiece of Bijapur painting, now damaged by flaking, a venerable Sufi is seated on a prayer platform of his shrine retreat. With his hunched frame and overgrown beard and nails, he is clearly a recluse of some sanctity. The shrine has a low dome with pennants flying from a bamboo flagstaff, a group of Shi'ite religious standards, and between them, a luxuriant banyan with a large white parrot and a waterskin on a tripod below. On the left, bullocks are watered from a trough and a monkey could originally be seen on a perch: such obliterated details are fortunately preserved in an eighteenth century copy by the Oudh painter Mihr Chand (fig. 5).

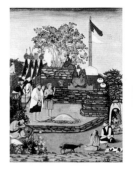

A dervish visitor in a shawl of penitential white is being introduced by a younger companion holding a flywhisk and drum. The visitor's eyes are closed, in humility or perhaps because of blindness. Like most of the figures present, he bears ritual marks on his fore-arms. He too is a person of consequence, for a seated fakir in the foreground gestures towards him, while cosseting a fat-tailed sheep, glowingly stippled in gold and black. The other fakir beside him (his face now lost) also gazed at the visitor.

We do not know who the dervish and his visitor are. It has been remarked that the latter bears a resemblance to Sultan Ibrahim Adilshah of Bijapur, a great connoisseur of music, art, and poetry, for whom this picture was very probably made. Could the Sultan have chosen to be depicted as a dervish humbling himself before a revered shaikh? Because of his unorthodox leanings towards Hindu culture, Ibrahim is known to have been rebuffed by several eminent Bijapur Sufis of the time. One of these, Shah Abu'l Hasan Qadiri, succeeded in diverting him from his devotion to a Hindu yogi who was said to have revived the Sultan's dead daughter by singing a raga to her. However this may be, it remains a painting of great refinement, combining brilliantly detailed observation with a pervasive mood of serenity.

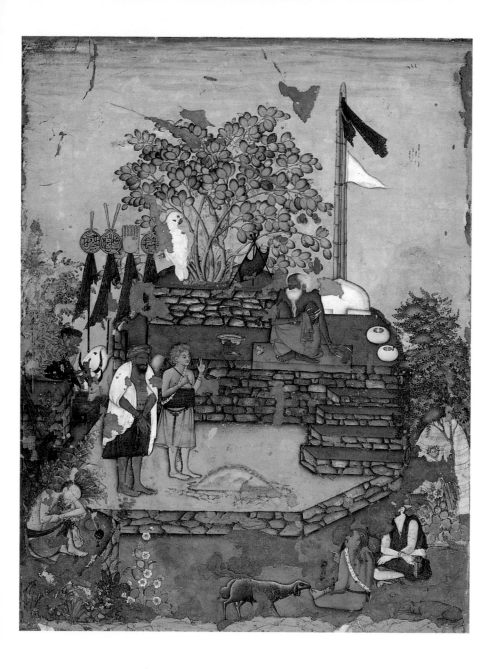

31

13 Shah Jahan enthroned
Mughal, c.1638
Gouache with gold on paper; 24.2 × 14.3 cm
Bodleian Library (MS Douce Or.a.1, f.9r)

Under the Emperor Jahangir Mughal portraiture
reached its zenith, not only in the dispassionate record-
ing of human individuality (**9**) but as a means of imperial
self-aggrandisement. Under Shah Jahan (1627–58) this
propagandist strain became dominant. Here he is sym-
bolically shown as World Ruler (as his name signifies).
Seated on an ornate throne, probably at Agra Fort, he
holds a jewelled lance and an orb representing heaven
and earth. Such ceremonial enthronements were part of
the elaborate court ritual. In October 1637 the tenth
anniversary of Shah Jahan's accession was celebrated:
In commemoration of the occasion, the King of the seven
climes proceeded with God-given fortune to the Forty-
Pillared Hall of Public Audience and ascended the Jewelled
Throne. According to the yearly custom, gold and pearls
were lavishly distributed from his munificent hands, and
fell upon his obedient subjects like auspicious rays from
the all-powerful sun.[1]

Immersed in sumptuously coloured and patterned
surfaces, the Emperor assumes iconic status. His face in
profile is rendered with great finesse in the stippling
of flesh and treatment of the slightly greying hair and
beard. His radiant solar nimbus stands out from
the golden throne-back through the artist's textured
striation and stippling of the gold surfaces. The jewelled
throne, with pearl-fringed canopy, displays European
baroque features such as its foliated scrolling wings. The
throne cushions, carpet and the Emperor's surcoat, robe
and sash are an opulent mass of floral ornament. The
natural flowers set against the green background are
arranged with similar formality in this apotheosis of
imperial grandeur.

[1] W.E. Begley and
Z.A. Desai eds., The
Shah Jahan Nama of
'Inayat Khan, Delhi,
1990, p.219; and pl. 1

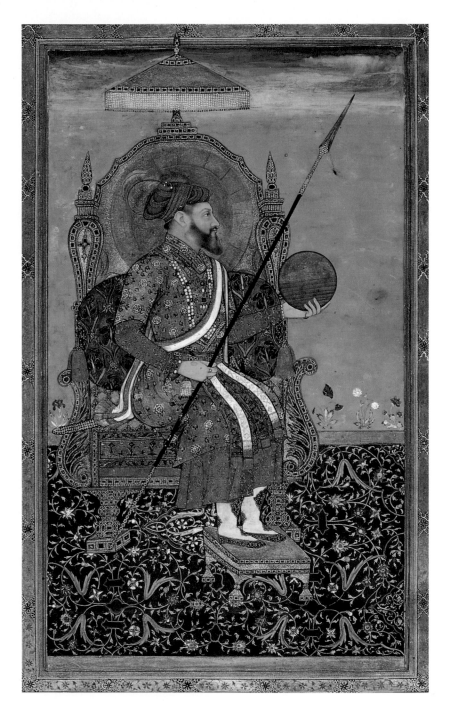

14　Shah Jahan receives 'Ali Mardan Khan

Mughal, c.1640. Attributed to Payag
Gouache with gold on paper; 34.5 × 23.8 cm
Bodleian Library (MS Ouseley Add. 173, no. 13)

In November 1638 Shah Jahan received with honour at Lahore the Persian general 'Ali Mardan Khan, who had helpfully surrendered to him the strategic frontier city of Qandahar. 'Ali Mardan Khan was rewarded with the governorship of Kashmir. He later rendered outstanding service as a designer of gardens, canals and other public works.

　　In this durbar scene the Persian nobleman appears among the throng of courtiers on the left, wearing a splendid flowered robe and saluting the Emperor with hand raised to his forehead. In keeping with the protocol of the time (so different from the informality of early Mughal court scenes, 2), the figures appear frozen in a tableau, depending hierarchically from the majestic figure of the ruler. Each is an acutely observed portrait. Attributable to the gifted and versatile artist Payag, this composition closely resembles the durbar scenes of the *Padshahnama*, the illustrated history of Shah Jahan's reign now in the Royal Library at Windsor, and was probably intended for that manuscript.

　　As in many of Shah Jahan's portraits (**13**), there is a well-developed imperial symbolism. Flanked by attendants with yak-tail fans, the Emperor is shown with a gold nimbus on the throne balcony in his hall of audience. The princes Dara Shikoh and Murad Bakhsh and the minister Asaf Khan stand to the left. Painted angels (inspired by European art, like the royal nimbus) gaze down from the walls. In the panel below the throne are depicted the scales of justice, the lion eating with the cow, and Sufi shaikhs holding a globe and sword. The Emperor is thus personified as perfect bestower of justice and peace, and master of both spiritual and temporal worlds.

　　Around 'Ali Mardan Khan are grouped Mughal courtiers and his own Persian entourage, who bring jewelled gifts and a string of horses for the Emperor. A closely related painting, formerly in a Benares private collection (fig. 6), shows the Persian nobleman being respectfully escorted by ministers to the hall of audience beforehand, with the royal musicians playing in the background.

Fig. 6 'Ali Mardan Khan being escorted to the hall of audience. Mughal, c.1640. Formerly Sita Ram Sah collection, Benares. (After N.C. Mehta, *Studies in Indian painting*, Bombay, 1926).

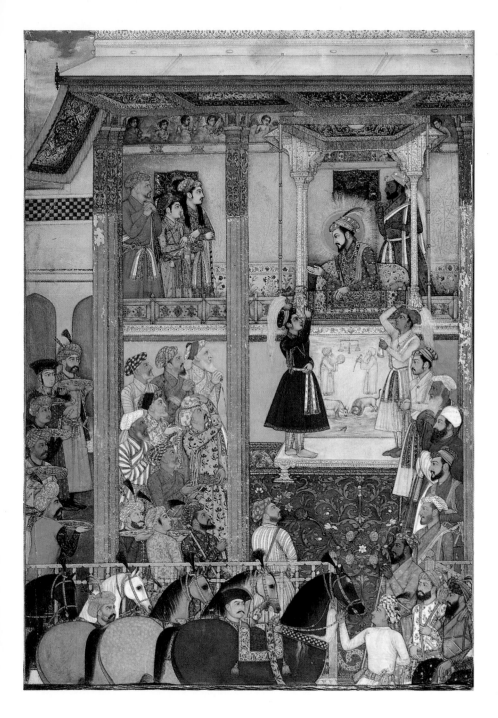

15 The minister Sa'dullah Khan presiding at an assembly

Mughal, c.1655
Gouache with gold on paper; 40.5 × 28.8 cm
Bodleian Library (MS Douce Or.b.3, no.21)

Sa'dullah Khan, the able and learned prime minister of Shah Jahan, presides over a durbar assembly on an open terrace. Enthroned under smaller and greater canopies, he gives orders or judgements to the officers ranked before him. A state elephant and caparisoned horses await the minister and grandees in front of the partition railing. To the fore of the crush of attendant figures on the left are two Europeans in ruffs and black hats.

Shah Jahan prized his loyal minister and deeply mourned his death in 1656, two years before his own dethronement by his son Aurangzeb. This painting of Sa'dullah Khan shows him as the authoritative executive of the Emperor's will, with the entourage and panoply appropriate to his office. The Mughal state machine is seen in smooth and ruthless action. The over-arching canopy strikes a grandiloquent note with its gold brocade interior with flowering scrollwork, the latter amplified above in the less disciplined, more ominous rhythms of the tightly bunched cloud curlicues.

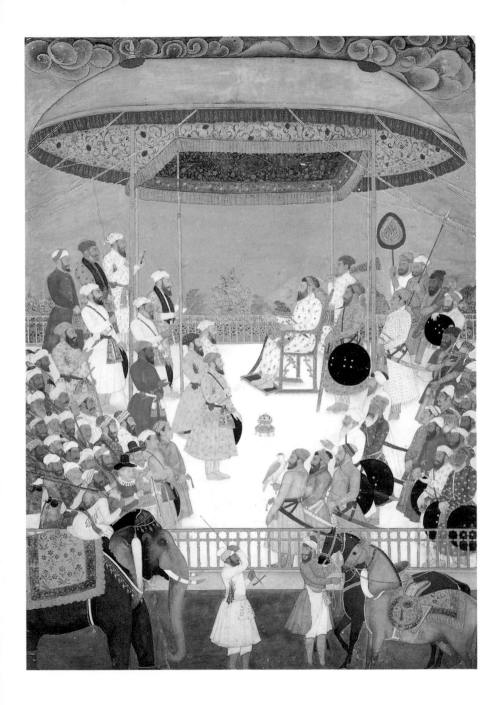

16 A prince with a narcissus

Mughal, c.1640-50
Gouache with gold on paper; 17.2 × 11.5 cm
Bodleian Library (MS Douce Or.a.1, f.45v)

In the more introspective mode of Mughal painting (2), princes are shown withdrawn from the tumult of hunting, war and court ceremonial, absorbed instead in solitary contemplation with a book, flower or wine-cup in secluded gardens, in the society of a favourite concubine, or else in solemn spiritual discussion with greybeard shaikhs.

In this painting a young prince of refined sensibility sits on a high-backed chair among flowering shrubs and slender trees. Wine-flasks and cups and a vase of flowers stand within reach. He is lost in reverie as he smells a narcissus; in Persian poetry narcissi are associated both with the spring and with the languorous eyes of the beloved. The subject, setting and palette recall the Persianate aestheticism found in earlier Deccani painting and in the work of the artists Farrukh Beg and Muhammad 'Ali. A contrasting note of agitation is struck by the Mughal hunting carpet with a leopard pursuing blackbuck, which seem to wheel about the flower-vase.

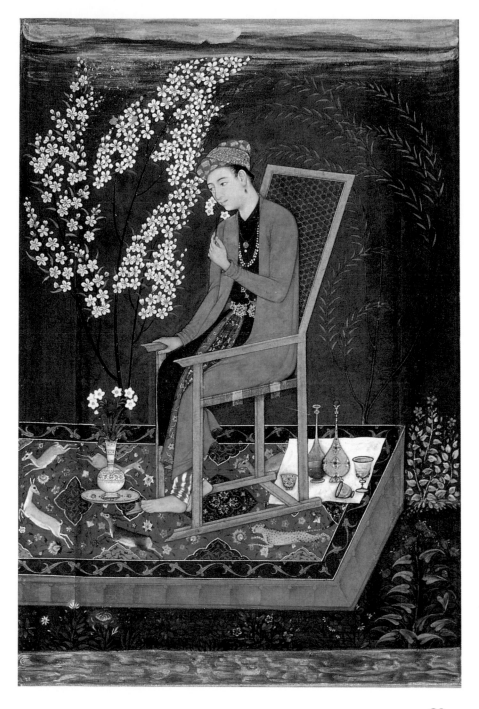

17 Sultan 'Abdullah Qutubshah of Golconda

Golconda, Deccan, c.1640
Gouache with gold and silver on paper;
12.5 × 9.8 cm
Ashmolean Museum (EA 1960.203)

As Mughal domination of the Deccan increased during the seventeenth century, imperial conventions of portraiture (**13**) became influential in the now tributary Sultanates of Golconda and Bijapur. The local artists tended to reinterpret these models with a subtle richness of colour and a poetic, often languorous, quality that is typically Deccani.

The youthful Sultan 'Abdullah Qutubshah (r. 1626–72) had been compelled to accept Mughal sovereignty in 1636. In a painting of slightly later date, he is shown seated formally on a low throne set on a terrace with an attenuated garden beyond. He displays a radiant nimbus of Mughal type, while his hand rests martially on his sword-hilt. In reality 'Abdullah was indolent and ineffectual: 'all his time was given to ingenious forms of sensuality' (Sir Jadunath Sarkar). His administration was run by his mother. The Sultan's character is conveyed less by the sword and nimbus than by the refined modelling of his dreamy, thick-lipped countenance, combined with the decorative splendour of his flowered gold robe.

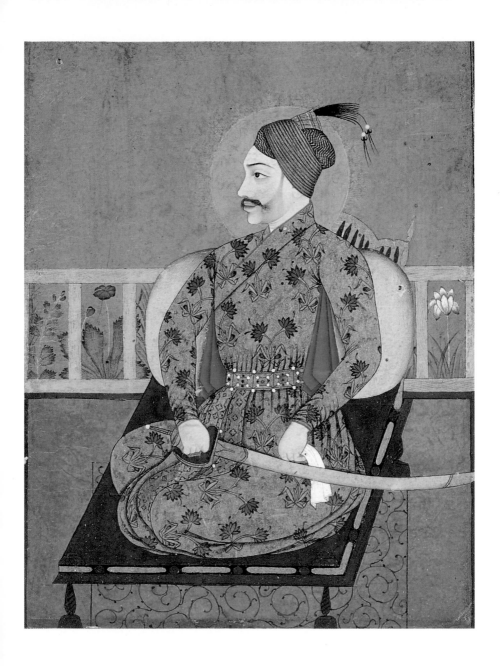

18 Prince Ram Singh of Amber at worship
Amber, Rajasthan, c.1660
Gouache with gold and silver on paper; detail
17 × 12 cm. approx
Ashmolean Museum (EA 1994.46)

The Rajput prince Ram Singh of Amber (b.1635) performs his devotions in a garden setting. Bare-chested and with hair tied back, he recites invocations or mantras with the aid of prayer-beads held under the end of his muslin shawl. Ablution vessels are placed before him, with a conch-shell on a stand and brass stamps and sandal-paste for imprinting sectarian marks. The small raised platform on which he sits is set at an unusually oblique angle to the background, with its blossoming trees and massed clouds. The clouds were partly repainted when the picture (which had been trimmed) was enlarged by a less skilful artist, before being mounted in its album page (fig. 7). While the sensitive portraiture, with fine stippled shading of the face and torso, indicates that the artist had received Mughal training, the freer interpretation of the setting suggests this may be an early work of the local Amber (later, Jaipur) school.

Ram Singh is reputed to have been a devout Hindu and less happy than his predecessors in his required attendance at the Mughal court under Aurangzeb. He earned the lasting displeasure of the Emperor, who suspected him of complicity in the escape of the Maratha leader Shivaji from Agra. When Ram Singh became ruler of Amber in 1667, Aurangzeb sent him off to govern the remote and unhealthy border region of Assam in the north-east. But he survived this. Further postings followed on the north-western Khyber frontier, where Ram Singh died in 1688.

Fig. 7 Prince Ram Singh of Amber at worship: album page (48.8 × 34.6 cm.), late seventeenth century, showing the enlarged painting area and gold floral border decoration, with Persian and devanagari inscriptions identifying the subject.

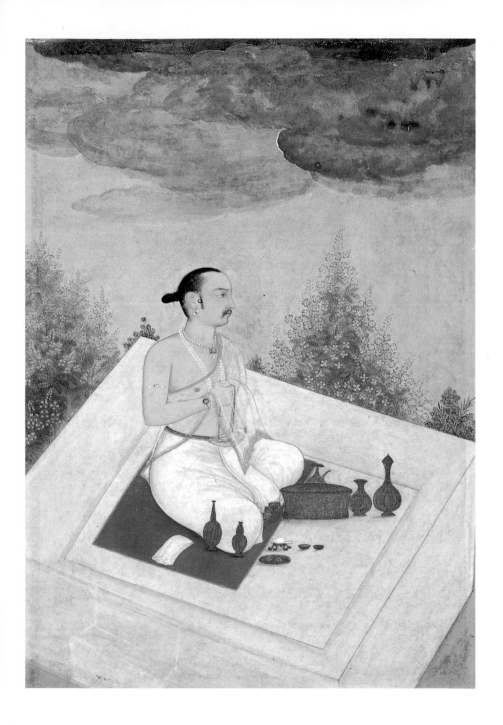

19 A hero greeted by princes

Illustration to the musical mode Kanada ragini
Bikaner, Rajasthan, c.1680. By Ruknuddin
Gouache with gold on paper; 16.2 × 13 cm
Ashmolean Museum (EA 1990.6; *purchased with
the help of the Friends of the Ashmolean*)

The musical mode Kanada (or Karnata) is named after
the Karnataka region of South India, where it may have
originated as a hunting melody. This ragini is visualised
as a princely warrior, blue-skinned like the god Krishna,
who has shown his valour by slaying an elephant. He
holds a sword and a severed tusk and he wears a sliver
of ivory in his right ear. Since elephants were far too
highly valued in India to be hunted in this way, the sub-
ject may allude to the story of Krishna's defeat of
Kuvalayapida, the demonic elephant of the wicked King
Kamsa. Greeting the victorious hero with raised hands
are a Rajput prince and his younger companion. An
attendant waves a fly-whisk, an emblem of royalty.

This picture is an example of the refined style
developed in the late seventeenth century by immigrant
Muslim artist families at the Rajput court of Bikaner, in
the deserts of western Rajasthan. This early Bikaner
style combined Mughal technique with influences from
the Deccan. The Maharajas of Bikaner spent long
periods campaigning with the imperial armies in the
Deccan or serving there as military governors. The dis-
persed ragamala series to which this page belonged was
made for Maharaja Anup Singh (b.1638, r.1669–98) by
his leading artist, Ruknuddin. The conventional icono-
graphic grouping of the four standing figures is treated
by Ruknuddin with Mughal finesse of line and Deccani
subtlety of colouring.

As well as being a successful general, Anup Singh
was a Sanskrit scholar and notable patron of the arts. He
had a particular love of music, preserving important
musical treatises in his library and employing at Bikaner
talented performers who had been banished (like
the imperial painters) from the court of the pious
Aurangzeb. In this painting the leading prince who
greets the elephant-slayer resembles portraits of Anup
Singh. Such an identification with his patron may
perhaps have been intended by Ruknuddin. Anup
Singh's military career in the south mainly took place in
eastern Karnataka, the region which lends its name to
this ragini. It was there, as governor at Adoni, that he
eventually died.

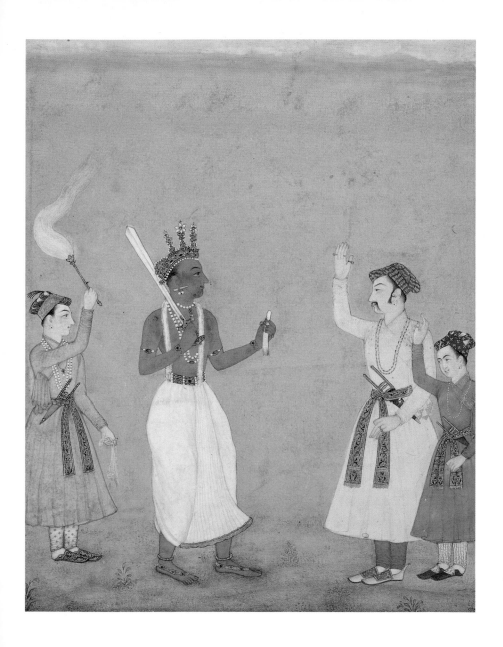

20 Lovers at daybreak
Illustration to the musical mode Raga Vibhasa
Northern Deccan or southern Rajasthan,
c.1675
Gouache with silver and gold on paper;
19.7 × 15 cm
Ashmolean Museum (EA 1991.154)

Vibhasa ('brightness' or 'radiance') is a musical air played at dawn. Its pictorial image is a noble couple who have passed a night of love together. At daybreak the lady remains languorously asleep on the intricately patterned coverlet. Her lover rises and puts on one slipper, while brandishing a luxuriant floral bow and arrow, like that of the love-god Kama. In some versions he is shown aiming an arrow at a cock crowing, as if to prevent day from coming. But here the peacock on the roof remains unscathed.

An atmosphere of muted splendour is created by the artist's confident use of decorative detail and the combination of warm colours with more modulated tones. While the iconography and motifs such as the gold sun with human face adhere to the Rajasthani pictorial tradition, the palette suggests Deccani influence. Rajput nobles serving with the Mughal forces in the Deccan patronised local artists or occasionally brought them back to Rajasthan. It is uncertain where this particular ragamala was painted. It has a Rajasthani provenance, attested by old inventory marks from the Mewar royal collection. Twenty-one of its pages are known to survive, of which two are in the Ashmolean.

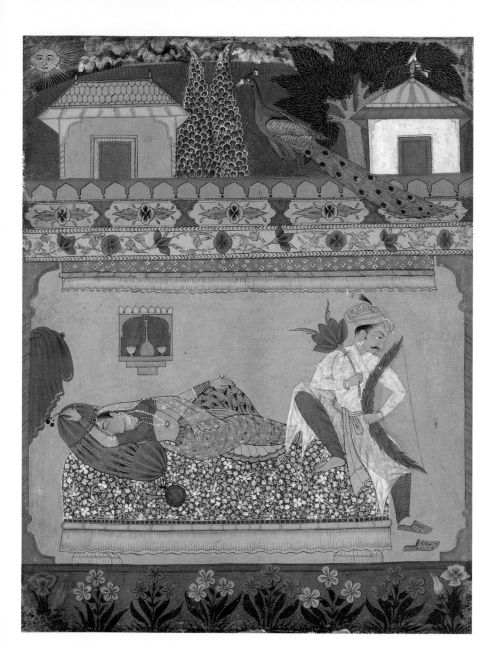

21 Maharana Raj Singh I of Mewar riding

Udaipur (Mewar), Rajasthan, c.1670
Gouache with gold on paper; 29.2 × 23 cm
Ashmolean Museum (EA 1991.153)

The Maharanas of Mewar, whose ancestors tenaciously resisted successive Muslim invaders, are considered the premier Rajput chiefs. They capitulated to the Mughals only in 1615, forty years after their fellows, and on terms allowing them a greater degree of independence. For much of the seventeenth century Mewar artists continued to produce robustly expressive manuscript illustrations deriving from the indigenous Early Rajput style. Mughal conventions of portraiture only became established at Udaipur towards the end of the century.

In this early example of Mewar portraiture, Maharana Raj Singh (r.1652–80) rides a rearing, dappled blue horse, starkly silhouetted against a sheer red ground. He wears a flowered gold robe of Mughal type, and he had in fact attended the imperial court as a prince. But his portrait typically reveals an ideal of Rajput martial heroism more than a closely observed individual. His moustache is flowing, his eye staring and slightly bloodshot. He raises a hand in a gesture of command. Above a thickly brushed white horizon a gold sun blazes, symbolising the legendary descent of the Mewar chiefs from the Sun-god; the gold and black royal parasol held by an attendant is also a solar symbol. The Maharana's heroic aspect is appropriate, for he was the last Mewar ruler to be a successful warrior. A very similar portrait of Raj Singh, with an olive-green background, is dated 1670 (present location unknown).

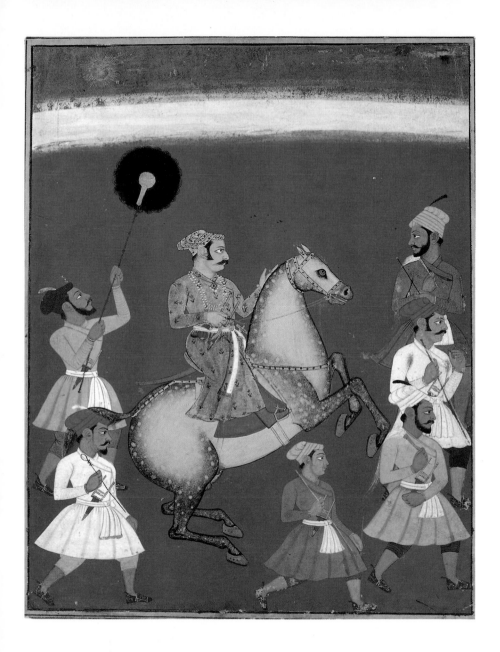

22 Maharana Amar Singh worshipping at Eklingji

Udaipur, Rajasthan, c.1700–05
Gouache with gold and silver on paper;
48 × 55 cm
Ashmolean Museum (EA 1989.40; *Purchased with the help of the Friends of the Ashmolean*)

Maharana Amar Singh II of Mewar (r.1698–1710), the grandson of Raj Singh I (**21**), is seen at worship at the temple of Eklingji, attended by priests, musicians and the royal entourage. A manifestation of Shiva, Eklingji is worshipped in the form of a lingam (phallic icon) with four human faces. He is the ancient tutelary deity of the Mewar rulers. Royal processions from Udaipur, the capital from the late sixteenth century, to the temple of Eklingji, in a hilly defile to the north, were a regular state function.

Amar Singh sits before the deity, which is adorned with jewels, garlands and canopies and cobras in gold and silver. A Brahmin priest and assistant officiate. In the courtyard, attendants carry regalia and musicians of the court and temple play horns, cymbals and drums. Other members of the royal escort stand outside in the temple enclosure. Beyond the outer wall, mahouts and grooms wait with the elephants and horses. The temple architecture is depicted schematically, but with enough detail in the superstructure to be recognisable. The agile temple monkeys and their young are seen on the roofs and in the wooded background.

Brush drawing on a plain ground predominates and colours and gold are only sparingly used, yet this is a completed work. It is an exceptionally large and elaborate example of the finely stippled semi-grisaille style often employed by the leading artist of Amar Singh's reign. This anonymous master did much to consolidate Mughal conventions of portraiture at Udaipur, though these were thoroughly assimilated to the bolder Rajput vision. Here, the delicate execution of individual figures and animals is combined with a deliberately simplified setting.

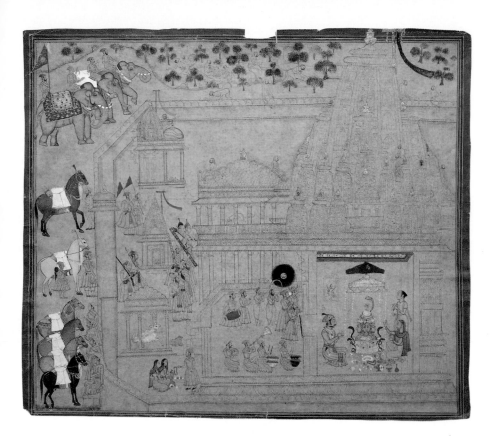

23 Muhammad Shah riding

Mughal, *c.*1720–25
Gouache with gold and silver on paper;
39 × 26.8 cm
Bodleian Library (MS Ouseley Add. 173, f.27)

In the reign of Muhammad Shah (1719–48) the Mughal empire crumbled but art continued to flourish. Known as Rangila ('Pleasure-loving'), the insouciant Emperor devoted himself to the enjoyment of poetry, music, fine wine and food and beautiful women. If news arrived of some military setback he would console himself by contemplating his magnificent gardens. This went on for twenty years. But in 1739 Nadir Shah of Persia sacked Delhi and took away a huge treasure, including the Peacock Throne of Shah Jahan.

If Muhammad Shah's empire was more show than substance, so also is this portrait, in which he strikes a martial attitude borrowed from equestrian portraits of the genuinely bellicose Aurangzeb, some sixty years earlier. He appears helmeted, chainmailed and armed with lance, bow and quivers in readiness for battle. He displays not just one but a double radiant nimbus. His rearing charger also is splendidly armoured, hennaed and tasselled. The background is the traditional pale green of earlier Mughal portraiture, and the foreground receding to a near horizon is strewn conventionally with flowers and grass tufts. Above, a portentous gold-red light fringes the puffy snailshell clouds. High among the clouds, the Emperor's name is inscribed in tiny letters. The illusion of imperial glory is evoked with the technical mastery of the Mughal studio in better days.

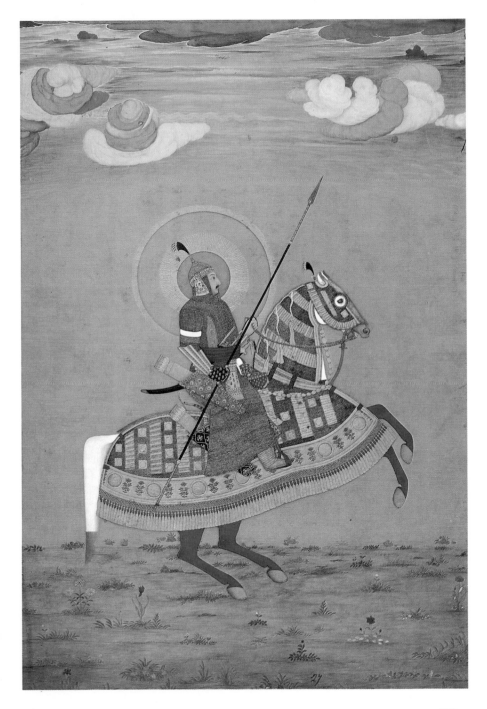

24 **Muhammad Shah with courtiers,**
25 **and playing Holi with ladies and musicians**
 Mughal, c.1730, and 1738–39 (by Bhupal Singh),
 respectively
 Gouache with gold on paper; 31.2 × 46.8 cm;
 34 × 45.9 cm
 Bodleian Library (MS Douce Or.a.3, f.14;
 MS Douce Or.b.3, no.22)

In these two paintings the sybaritic Emperor Mu-
hammad Shah (**23**) is shown taking his ease among
marble halls with his courtiers, ladies and musicians.
Cool whites and greys dominate these palace scenes,
relieved by colourful rugs and hangings placed with
geometrical formality. The court no longer appears
thronged by officials and attendants, as in earlier peri-
ods. The empty palatial spaces verge on a melancholy
vacuity; the human figures in them can also appear
remote.

There is still great refinement in the symmetrical
setting in which the hookah-smoking Emperor receives
his courtiers round an ornamental pool (**24**), the shad-
owy central doorway behind him flanked by uniform
rows of furled blinds and wall-niches with flower-vases
or fruits. The schematic rectangularity is accentuated by
the bold vertical red poles (to support an awning), which
also frame the figures of Muhammad Shah and four of
his ministers or governors. These individuals were as
corrupt and ambitious as the Emperor was incompetent.
Those on the right are identified as Khan Dauran and the
minister Qamaruddin Khan(?). On the left are Sa'adat
Khan Burhan al-Mulk and (with a prominent belly)
Roshan ud-Daula, a wealthy intriguer who fell into
disgrace in 1732.

The same symmetries of architecture and colour-
ing are seen, from a more distanced viewpoint, in
Muhammad Shah playing Holi with ladies (**25**). Holi is a
lively, often rowdy, rite of spring, in which coloured
powder and water are hurled about with abandon. In
observing this Hindu festival Muhammad Shah was
reverting to the cultural syncretism of Akbar. An ener-
getic Holi battle has clearly already been waged on the
colour-stained marble terraces: the Emperor holds both
a water-syringe and a powder missile at the ready. But
he appears stilled and captivated by the Holi song of the
singer Gulab Bai and her band.

54

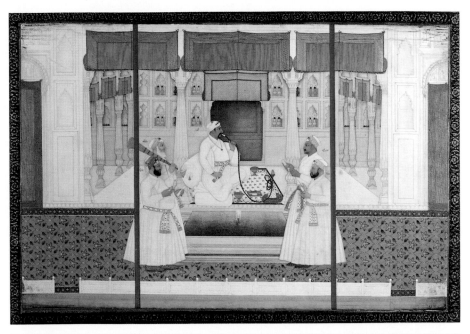

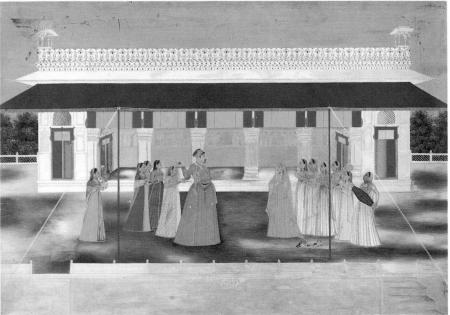

55

26 Hunters and ladies in a landscape
Mughal, *c.*1740
Gouache with gold and silver on paper;
27 × 36.3 cm
Bodleian Library (MS Douce Or.b.3, no.29)

A Mughal nobleman in hunting green, identified as Jamalullah Khan, takes aim with the matchlock resting on an attendant's shoulder and shoots a blackbuck which has been lured by tame decoy deer. Similar hunting subjects appear in Mughal painting from the Shah Jahan period onwards. Like much eighteenth century work, this is a variation on a familiar theme, in this case piquantly combined with the subject of ladies bathing.

The receding hilly landscape, influenced by European models, reveals riverine vistas and distant townscapes under a sky suffused with gold. The prince's retinue waits behind a wooded rise on the left. In the centre, prominently superimposed on the landscape – indeed overpainted on it, and hence an afterthought – is an enclosed tank with domed corner pavilions and flowering lotuses. Here women fetch water or bathe, in playful contrast to the solemn watchfulness of the hunters.

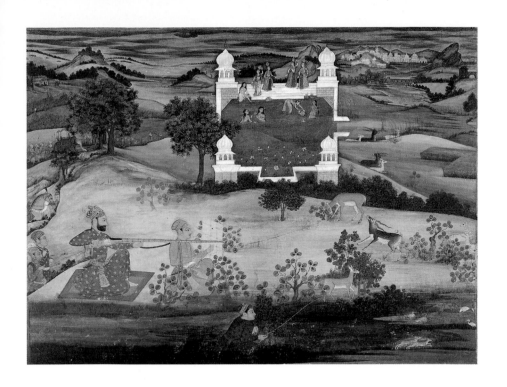

27 Baz Bahadur and Rupmati

Kulu (?), Punjab Hills, *c*.1720
Gouache with gold and silver on paper;
21 × 25.7 cm
Ashmolean Museum (1958.307; *Gift of Prof. R.C.Oldfield*)

A cultivated prince and gifted singer, the Muslim Sultan Baz Bahadur of Malwa was devoted to the company of musicians and dancing-girls. His favourite was Rupmati, a celebrated beauty who became his constant companion. Their idyll ended when Baz Bahadur was defeated by the Mughal general Adham Khan in 1561. His harem fell into enemy hands and Rupmati took poison to escape dishonour.

The love of Baz Bahadur and his Hindu mistress became a popular theme of poetry and song in late Mughal India. At the provincial Mughal courts and in the Punjab Hills the lovers were commonly depicted riding together, often on moonlit nights. Such romantic themes had a strong appeal for the Muslim and Hindu nobility alike, for whom the conventions of purdah precluded free association between the sexes.

In this painting the lovers' horses advance in step, wild-eyed and with teeth bared. Baz Bahadur, a hawk held on his gloved wrist, gazes entranced at Rupmati, who turns in the saddle to regard him. Their figures are silhouetted against a cool grey ground, around which compact, bushy trees cluster in quasi-amorous pairs, entwined with sinuous creepers and trailing lissom fronds. A strong red border, common in Rajput painting, complements the scene.

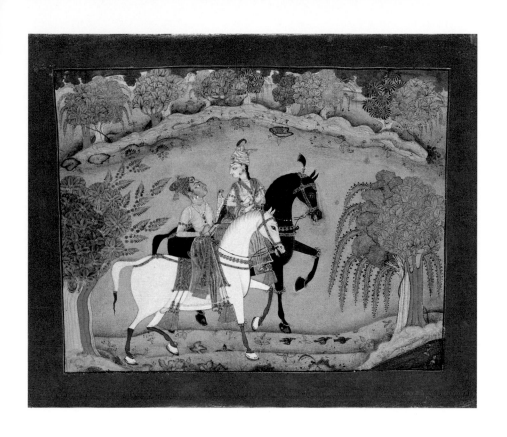

28 Hunters and a tiger in a landscape

Hyderabad, Deccan, mid-eighteenth century
Gouache with gold and silver on paper;
21.6 × 39.5 cm
Bodleian Library (MS Douce Or.a.3, f.8)

The strong current of poetic fantasy in Deccani painting appears in this bird-filled landscape, with palms and outcrops of heaped boulders like those around Hyderabad, under a gold-streaked sky with flying cranes. Recession and scale are treated in an *ad hoc* way: a tree of great size grows on the far right. Towards the centre, a large snake is coiled round a tree, while another is apparently immolated in a fire.

Also enigmatic in its symbolism is the main subject of three hunters in khaki and green, whose approach seems already to have been sensed by the alert blackbuck. The prominent, pale-skinned leading figure is perhaps intended for a nobleman. He holds a flower-sprig and light stick, and, more curiously, wears a cobra entwined in his belt. The second huntsman holds two decoy deer on leashes. The third figure looks back unperturbedly at the tiger with bared fangs padding docilely behind them.

This unusual scene evidently illustrates a poetic theme: the hunters, who are also the keepers of the tiger, are engaged in a hunt of an allegorical kind. A Persian verse inscribed on a sheet attached to the painting can be translated: 'The lion [or tiger]-keepers are hunting heaviness of heart.'

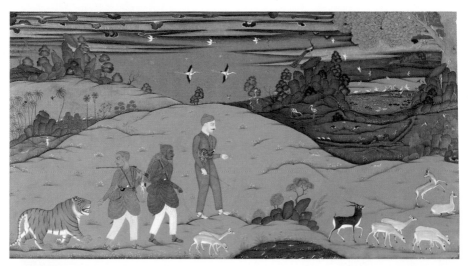

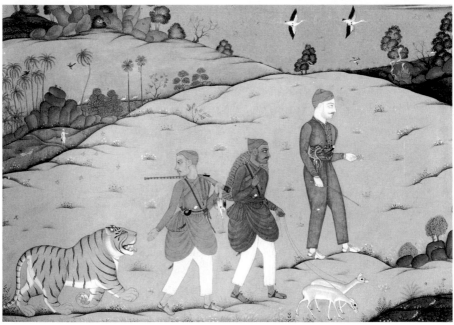

29 Actors performing a drama

Provincial Mughal style in Oudh (Lucknow or
Faizabad), *c.*1760. Attributed to Mir Kalan Khan
Gouache with gold and silver on paper;
32.8 × 19.6 cm
Bodleian Library (MS Douce Or.b.3, no.20)

A melodramatic entertainment is staged in a rustic
grove. Above, an actor playing a young prince strikes a
protective pose beside a bashfully half-veiled lady, while
another warrior figure withdraws. In front of them, a
female singer and musicians perform before a portly
lord, also presumably part of the play since he lounges
grandly against a crouching man pretending to be his
pillow, and he is fanned with a leafy branch by a buffoon
with a slipper tied to his turban.

On the right, watching these exciting or droll
goings-on, are a seated noblewoman smoking a hookah,
who is given a running commentary by an old crone,
and a raffish group of wine-drinkers including a be-
spectacled greybeard. The mood of intoxicated abandon
or deranged hilarity is further accentuated by the figures
in the foreground, including some Hindu ascetics, who
are sieving, pounding and no doubt consuming *bhang*
(marijuana). One thirsty *bhangi* receives a drink of water
from a *bhisti* (water-carrier). Two others play on a jew's
harp and an empty clay pot.

This eccentric gathering shows a witty improvis-
ation on different genre subjects (a lady watching an
entertainment; assemblies of holy men or drug addicts),
attributable to the virtuoso eclectic artist Mir Kalan
Khan.

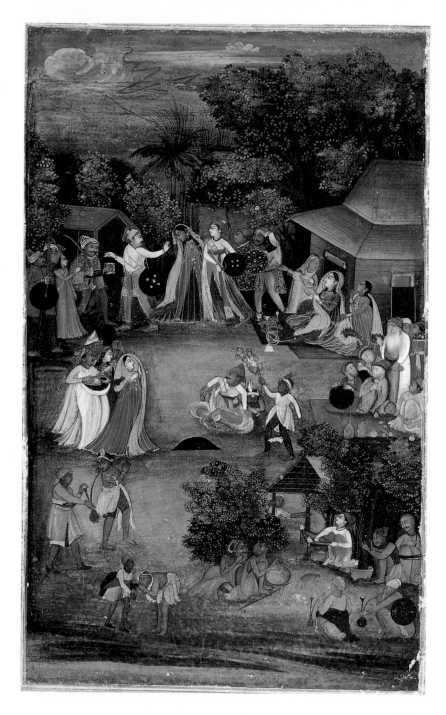

63

30 Ladies visiting holy men at night

Provincial Mughal style in Oudh (Lucknow or Faizabad), c.1760. Attributed to Mir Kalan Khan
Gouache with gold on paper; 24.4 × 16.3 cm
Bodleian Library (MS Douce Or.b.3, no.10)

In the eighteenth century scenes of princes or princesses visiting the abodes of holy men, either Sufi dervishes or forest-dwelling Hindu yogis, had become a commonplace of Mughal painting. Sometimes these scenes are nocturnal, allowing a modified use of European chiaroscuro. This late treatment of the subject has an air of fantasy (and unusual religious syncretism) typical of the eclectic painter Mir Kalan Khan (29).

A group of ladies have come by night to honour a white-bearded Muslim divine, seated by a tent or awning with garlanded Shi'ite religious standards; the leading noblewoman kneels to offer him a dish of pomegranates. Seated beside the shaikh is a venerable yogi with coiled, matted locks and grey, ash-smeared skin. Clasping a peacock-feather fan in the manner of an attendant, he too receives the ladies' respects. The other figures are a strange and fanciful party of grey-skinned and pink-garbed yogis, male and female, some only boys. They make music, smoke or perform a curious sword dance. The youth piping on a sinuous horn probably has a European antecedent. The densely leaved trees also show Western influence. With its deep contrasts of light and shade, this is a strongly moody variation on a well-known theme.

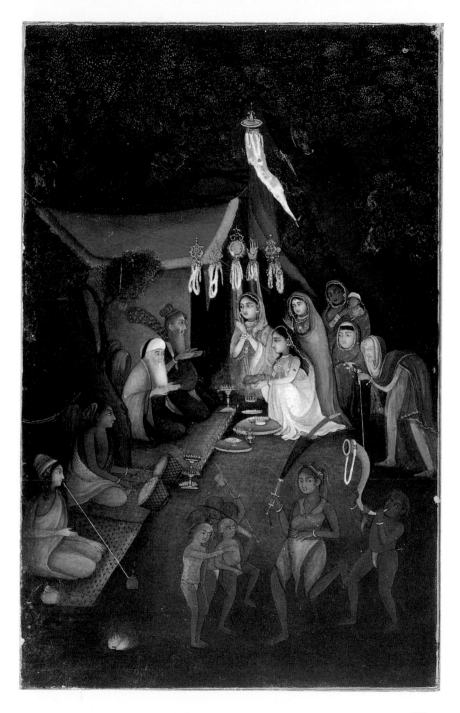

31 Saif ul-Muluk and Badi' al-Jamal with jinn attendants

An episode from *The Thousand and One Nights*
Provincial Mughal style at Farrukhabad,
c.1760–70
Gouache with gold and silver on paper;
24.5 × 18.3 cm
Bodleian Library (MS Pers.b.1, f.15r)

The wonder-tales and romances of the kind enjoyed by the young Akbar (**1, 4**) appealed as greatly as ever to the escapist mood of the late Mughal period, and were often illustrated at the courts of Oudh and elsewhere. The fantastic tale of Saif ul-Muluk, a prince of Egypt, and Badi' al-Jamal, a princess of the Jinn ('genies' or superhuman beings) is taken from the great Arabic compendium, *The Thousand and One Nights*.

As a result of earlier events, Prince Saif ul-Muluk falls irresistibly in love with a magical portrait of the Jinn princess. Only after worldwide travels, shipwrecks, kidnappings, the deployment of a magic ring and other interludes are the couple at last united. In this happy dénouement Badi-al Jamal embraces her new husband as they speed along in a gold aerial palanquin borne by monstrous but amiable jinn. Winged female attendants fly alongside on swift and manoeuvrable puffy clouds, fanning the royal couple and plying them with grapes, fruits and celestial liquors. The forest below bursts with blossoms and fruit, the lake with lotuses.

With its stylized, broad-cheeked figures and a general crowding of detail, such work stands near the end of the Mughal tradition. Yet the artist has still responded with zest and charm to the climax of the wonderful tale.

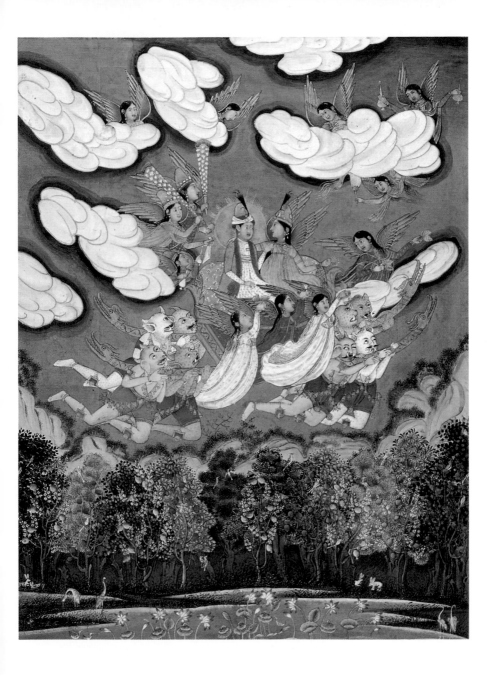

32 A royal procession to Golconda;
33 Figures in a pleasure garden
 Hyderabad, Deccan, c.1775
 Gouache on paper; 27.5 × 33 cm; 23.6 × 33 cm
 Bodleian Library (MS Douce Or.b.3, no.25, 31)

These treatments by a Hyderabad artist of a royal pro-
cession and a palace garden are enlivened by his playful
experiments with perspective and borrowings from the
European topographical prints that were reaching India
in great numbers by the late eighteenth century. In the
procession scene, a ruler riding in a bright yellow ele-
phant howdah approaches a walled city over a long
bridge with multiple gates. On either side, women bathe
or wash clothes and ascetics gather in a grove.
Dominated by a lofty citadel within several rings of
walls, the city bears some resemblance to the old
fortress of Golconda, five miles from Hyderabad. Once
prosperous and famous for its diamond trade, Golconda
had been the capital of the Qutubshahi Sultans (16),
before falling to the Mughal Emperor Aurangzeb in
1687. The daily records of the early Nizams, rulers of
Hyderabad from the eighteenth century, record their
occasional brief stays at Golconda Fort, which was also
used as a state prison.[1]
 The Nizams' ceremonious excursions to the old
fortress must have inspired the present artist, who sup-
plied much else (such as the distant hilltop towns) from
his imagination. His human figures are stiff and undif-
ferentiated, and his stabs at architectural recession are
a jumble of divergent viewpoints. But this naiveté is
integral to his vision, along with a flair for detail and a
rich Deccani palette.
 The idealised vision of a princely pleasure-garden
is similarly overlaid with fantasy. Marble pavilions, ter-
races, cypresses, flower-beds and water-courses all
march away to inconsistent vanishing-points. The gar-
den is improbably peopled with a princess in the left
pavilion, a prince in the right, and a European-hatted
gentleman on the central terrace, all with their bevies of
maids and musicians. Other ladies lounge with musical
instruments in the foreground, and multi-coloured fish
swim round a fountain. Stranger still are the distant
European townscapes with exotic spires and towers.
Another version of the subject by the same painter, in
the Fondation Custodia, Paris, has an even stronger
European flavour and perspectival thrust.

[1] The chronology of
modern Hyderabad,
1720–1890, Hyderabad,
Government Central
Records Office, 1954,
e.g. pp.54–57

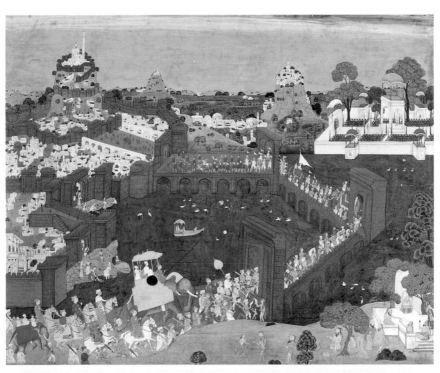

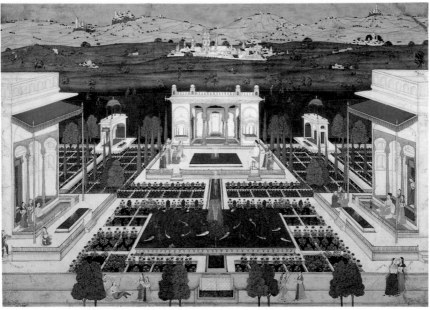

34 A commotion in the bazaar
Guler, Punjab Hills, *c.*1750
Gouache on paper; 20.8 × 29.8 cm
Ashmolean Museum (1978.2595, *Gift of Gerald
Reitlinger*)

While Mughal period painting gives an exhaustive pic-
ture of the life of the nobility, scenes of everyday life in
the teeming bazaars appear only occasionally, and then
usually as background to some royal cavalcade. A slice
of life such as this is all the more uncommon.

Armed officers have caught two thieves or felons,
one of whom suffers a humiliating public beating over
the head with slippers. The other, his turban askew after
a similar beating, is led away with a slipper held to his
head. A crowd has naturally stopped to stare, the
women peering from behind their veils. Elsewhere, life
goes on as usual: a young couple buy cutlery or trinkets
from a display spread on a cloth, and boys dance to
shehnai and drum music. On the right, two boys delib-
erate in front of a sweetseller's shop. In the foreground,
heedless of these distractions, a pink-robed Kanphata
yogi meditates at a lingam shrine to the god Shiva.

This damaged but lively and intriguing picture
shows elements of the style of Nainsukh, the most gifted
member of a widely influential family of artists working
at Guler and other Punjab Hill courts.

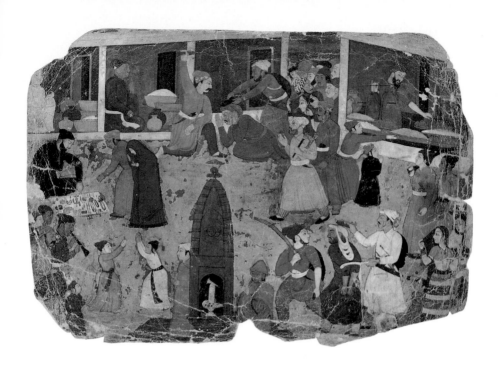

35 The meeting of eyes
An illustration to the Sat Sai of Biharilal
Kangra, Punjab Hills, c.1785
Gouache with gold on paper; 19 × 13.3 cm
Ashmolean Museum (*Mrs M.Barrett Loan*)

Krishna at a high window and a lady on a harem balcony
exchange a rapt and lingering gaze. Below them, two
women look on wonderingly. Beyond is an idyllic land-
scape. With delicate contrivance, the diagonals of the
balcony and wall converge on Krishna, who rests his
arms on the sill like a Raja displaying himself formally at
his palace window.

This painting belongs to a famous series of illus-
trations to the *Sat Sai* of Biharilal, which may have been
made for Maharaja Sansar Chand of Kangra. Bihari was
court poet to Maharaja Jai Singh of Amber in the seven-
teenth century. His *Sat Sai* comprises a notional 'Seven
Hundred' Hindi couplets, mainly on the theme of lovers'
meetings and secret emotions, in which the narrative
conventions of the Radha and Krishna cult are fused
with the traditional poetical typology of ideal heroes and
heroines.

Three verses inscribed on a leaf attached to the
picture[1] are all concerned with the sense of sight or
lovers' glances in particular. The most apposite here is
the second verse, in which the intense gaze between the
lovers is compared to a tightrope, stretched between the
roofs of houses, on which their hearts run back and
forth like acrobats.

[1] Numbered 57–59:
vv. 182, 193, 195 in
the Ratnakar edition

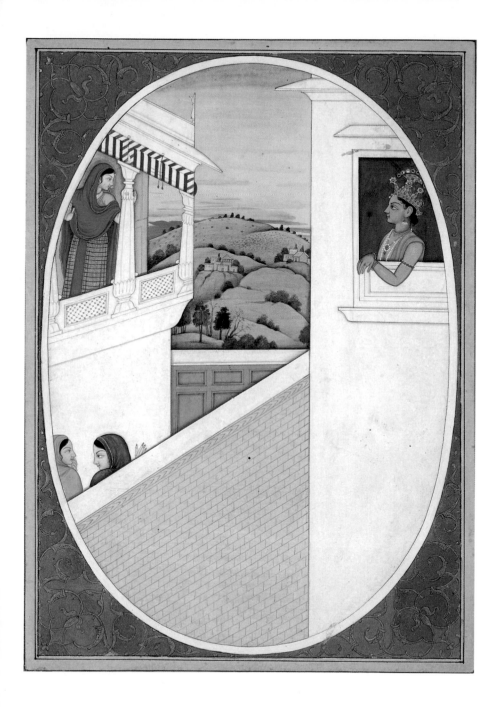

36 Maharaja Sawai Pratap Singh of Jaipur riding
Jaipur, Rajasthan, c.1782–85. By Ramji Das
Gouache with gold and silver on paper;
37.9 × 26.7 cm
Ashmolean Museum (EA 1992.115)

Pratap Singh (r.1778–1803) came to the troubled throne of Jaipur at the age of thirteen. In an age of dissolute princes and scheming courtiers, he is recorded in Tod's history of the Rajputs as 'a gallant prince and not deficient in judgment'. Like other rulers of the time, he could not hold off the invading Marathas and their voracious demands of tribute money. But enough wealth remained at Jaipur for the patronage of art and architecture. Pratap Singh's most impressive addition to the royal palaces was the Hawa Mahal (Palace of the Wind), its high facade a fantastic cluster of screened balconies, where his ladies could enjoy the breeze and watch the street below. He also maintained quite a large painting studio. Ramji Das (fl. c.1755–85) was a senior court artist, a portraitist of conventional but assured skills. Unusually, he produced many informal sketches of the minor officials, artisans, musicians, holy men and others attached to the court.

From this official royal portrait little of Pratap Singh's character can be discerned. Crisply refined and typically hard and sombre in style, it represents the final stage in the assimilation of the Mughal equestrian portrait convention at Jaipur. The haloed prince and caparisoned black stallion are outlined against a green ground with a narrow strip of sky, framed by a black border. An inscription records the horse's name as Dhajrao. The numerous royal entourage of earlier periods is reduced to a single attendant with a chowry (flywhisk). Even this humble individual has almost disappeared behind the horse; but his chowry-bearing hand remains proudly aloft.

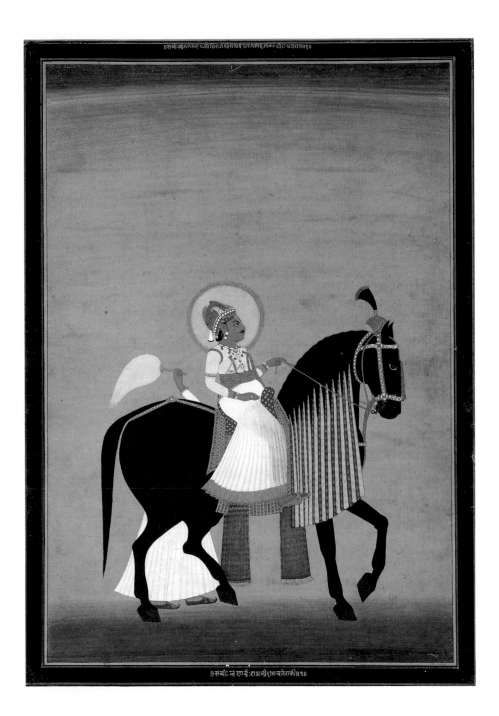

37 Maharana Bhim Singh of Mewar with a hawk
Udaipur (Mewar), Rajasthan, c.1805
Gouache with gold on cloth; 107 × 59 cm
Ashmolean Museum (1985.31, *Gift of the Friends of the Ashmolean*)

Shrewd and amiable but weak-willed, Maharana Bhim Singh ruled ineffectually for fifty years (1778–1828), though he fathered more than a hundred children. In this unconventional, half-lifesize portrait on cloth, he stands barechested and bejewelled, resting his weight nonchalantly on one leg and holding on his forefinger a hawk, also perched on one leg. The Maharana's hairy torso is lovingly delineated, and a splendid flowered gold sash swathes his ample hips. His head is more conventionally shown in raised profile within a radiant nimbus, the latter symbolising his descent from the Sun-god (**21**). Combining formal decorum with not quite subversive candour, this portrait can be attributed to Chokha, an individualistic artist whose best work for Bhim Singh (often portraying him enjoying the company of women) dates from the early years of the nineteenth century.

There was already in the Mewar royal collection an extensive and monotonous series of life-sized standing portraits of earlier Maharanas. Bhim Singh often had them brought out to show to James Tod, the British Political Agent, to assist their frequent historical discussions: [Bhim Singh] has a collection of full-lengths of all his royal ancestors, from Samarsi to himself, of their exact heights and with every bodily peculiarity, whether of complexion or form. They are valuable for the costume...[1]

Mostly dating from the late seventeenth century, they were by artists unable to make the transition from miniature work on paper to the grander scale of mural or cloth-painting. But Chokha's portrait of Bhim Singh is of a different order.

The picture has suffered some water damage, with paint loss on the turban in particular. An inscription on the squat, snub-nosed dog gives an old valuation of twenty rupees. A comparable work by Chokha is a cloth-painting of a voluptuous court beauty, in the collection of Sir Howard Hodgkin.

[1] J. Tod, *Annals and antiquities of Rajasthan*, ed. W. Crooke, London, 1920 (repr. Delhi, 1971), vol. I, p.358n

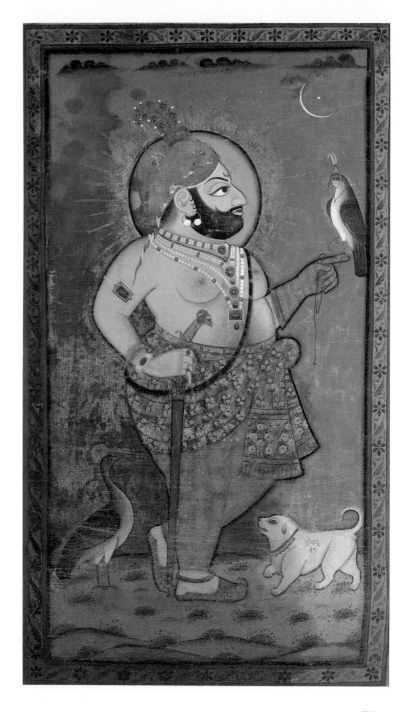

38 **A sarus crane**
Company school; painted for Lady Impey at
Calcutta, c.1780, by Shaikh Zain ud-Din
Gouache on paper; 94 × 59.5 cm
Ashmolean Museum (*Radcliffe Science Library
Loan*)

By the late eighteenth century many Mughal-trained
painters in eastern India were looking for patronage to
the emerging British ruling class. The products of this
new Company school were of varying quality. The most
common type was standardised sets of views of monu-
ments or of native castes, trades and festivals. But in a
few cases artists of distinction formed creative relation-
ships with individual patrons. Mary, Lady Impey, the
wife of Sir Elijah, the first Chief Justice at Calcutta, was
one such patron.

Arriving in India in 1774, the Impeys shared the
active scholarly curiosity about its life and culture pre-
vailing among the circle of Warren Hastings at Calcutta.
While Sir Elijah collected Oriental manuscripts and
paintings, Lady Impey assembled an aviary and
menagerie of indigenous species. She had these meticu-
lously recorded, where possible in life size, by three
Patna artists, of whom Shaikh Zain ud-Din was the most
gifted and prolific. Over two hundred such pictures were
produced before the Impeys returned to England in
1783.

Paintings of birds, animals and flowers had been
an important Mughal genre since the time of Jahangir
(1605–27), who was a keen amateur naturalist. Shaikh
Zain ud-Din's studies reveal a thorough adaptation of
Mughal technique to the conventions of British natural
history painting and the larger format of the imported
Whatman paper. But in his best works the Indian sensi-
bility remains. It appears here in the elegantly flowing
curvature of the standing crane and the arresting
colouring of its head and spindly legs, creating a height-
ened contrast with the subtle gradations of the finely
painted plumage.

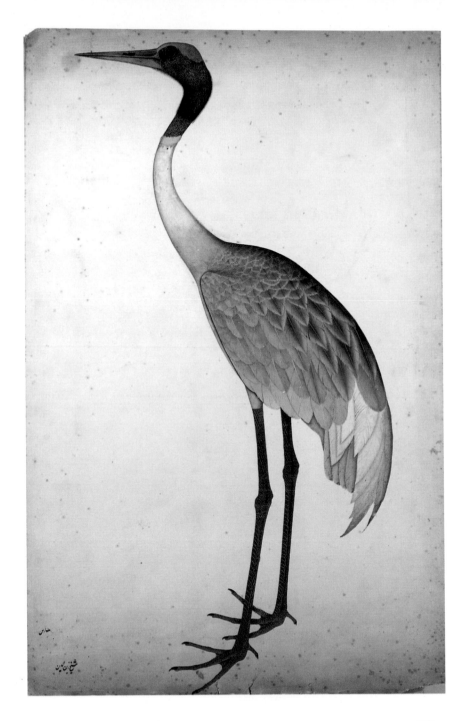

شیخ زین الدین

Further reading

The most useful survey of painting in the Mughal period is Milo Cleveland Beach's *Mughal and Rajput painting* (*New Cambridge History of India*, I:3), Cambridge, 1992. Other publications of recent years include the following monographs, introductory works and museum or exhibition catalogues:

M.C.Beach, *The Grand Mogul: Imperial painting in India 1600–1660*, Williamstown, Clark Art Institute, 1978.
_____ , *The imperial image: Paintings for the Mughal court*, Washington, D.C., Freer Gallery, 1981.
_____ , *Early Mughal painting*, Cambridge, Mass., 1987.

K.Ebeling, *Ragamala painting*, Basel etc., 1973.

D.J.Ehnbom, *Indian miniatures: The Ehrenfeld collection*, New York, 1985.

T.Falk and M.Archer, *Indian miniatures in the India Office Library*, London, 1981.

S.Gahlin, *The courts of India: Indian miniatures from the collection of the Fondation Custodia, Paris*, Zwolle, 1991.

B.N.Goswamy and E.Fischer, *Wonders of a Golden Age: Painting at the court of the Great Mughals*, Zürich, Rietberg Museum, 1987.
_____ , *Pahari masters: Court painters of Northern India*, Zürich, Rietberg Museum, 1992.

L.Y.Leach, *Indian miniature paintings and drawings*, Cleveland Museum of Art, 1986.

J.P.Losty, *The art of the book in India*, London, British Library, 1982.
_____ , *Indian book painting*, London, British Library, 1986.

A.Okada, *Imperial Mughal painters: Indian miniatures from the sixteenth and seventeenth centuries*, Paris, 1992.

P.Pal, ed., *Master artists of the imperial Mughal court*, Bombay, 1991.
_____ , *Indian painting: A catalogue of the Los Angeles County Museum of Art collection*, vol. I, Los Angeles, 1993.

J.M.Rogers, *Mughal miniatures*, London, British Museum, 1993.

A.Topsfield, *An introduction to Indian court painting*, London, 1984.
_____ , and M.C.Beach, *Indian paintings and drawings from the collection of Howard Hodgkin*, New York, 1991, and London, 1992; repr. London, British Museum, 1994.

S.C.Welch, *Imperial Mughal painting*, New York and London, 1978.
_____ , *India: Art and culture 1300–1900*, New York, Metropolitan Museum of Art, 1985.
_____ , et al., *The Emperor's Album: Images of Mughal India*, New York, 1987.

M.Zebrowski, *Deccani painting*, London, 1983.